pocket guides

VESTA BOXES

by

Roger Fresco-Corbu

Series Editor: Noël Riley

LUTTERWORTH PRESS
Guildford, Surrey

First published 1983

Cover illustration shows:

Left: Silver vesta box by the Birmingham silversmith Joseph Gloster; assayed in 1895 and presented to George Barnes Bigwood, actor-manager, in 1896.
Centre: Combination vesta box and cigar-cutter made of silver-plated brass. It advertises the French champagne Veuve Cliquot and was made in Vienna during the 1890s. Height 2⅝ in.
Right: Gilt brass decorated with painted enamel panels, back and front. Made in France during the last quarter of the 19th century.

Cover illustration and all black and white photographs in text taken by Hawkley Studio Associates Ltd.

ISBN 0–7188–2582–9

Copyright © Roger Fresco-Corbu 1983
Illustrations © Lutterworth Press 1983

No part of this book may be reproduced in any form, by print, photoprint, microfilm or any other means without written permission from the publisher.

Photoset by Nene Phototypesetters Ltd, Northampton

Printed in Great Britain by
Mackays of Chatham Ltd

Contents

Introduction		5
1.	Precious Metals	9
2.	Base Metals	22
3.	Metal Novelties	27
4.	Miscellaneous Materials	32
5.	Advertising	45
6.	Commemoratives	49
7.	Combination boxes	56
8.	Hints on Collecting and Price Guidelines	60
Books for further reading		63
Index		64

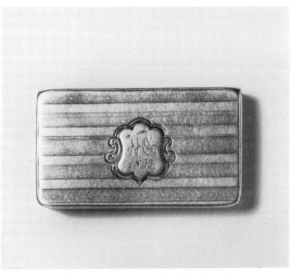

1. Silver, snuff-box style. Made by Alfred Taylor of Birmingham in 1853, 2⅛ × 1⅛ in.

Introduction

THE day in 1826 when John Walker, a chemist of 59 High Street, Stockton-on-Tees, invented the friction match is a landmark in the history of illumination. Where Walker led, others followed, and within a few years the world had a cheap and easy method of obtaining an immediate flame after centuries of tedious tinder-box manipulation and a few decades of cumbersome and costly 'instantaneous light' contrivances.

Today we take the match very much for granted, but let us consider the difficulties faced by our not too distant ancestors. S. Baring-Gould, in his *Strange Survivals*, published in 1892, gives an account of the performance involved in 'striking a light' earlier in the century:

'In the morning early, before dawn, the first sounds heard in a small house were the click, click, click, of the kitchen-maid, striking flint and steel over the tinder in the box. When the tinder was ignited, the maid blew upon it till it glowed sufficiently to enable her to kindle a match made of a bit of stick dipped in brimstone. The operation was not, however, always successful; the tinder or the matches might be damp, the flint blunt, and the steel worn; or on a cold morning, the operator would not infrequently strike her knuckles instead of the steel; a match, too, might often be long in kindling, and it was not pleasant to keep blowing into the tinder-box, and on pausing a moment to take breath, to inhale sulphurous acid gas and a peculiar odour which the tinder-box always exhaled.'

It is not surprising, therefore, that the Victorian economist and creator of the philosophy based on evolutionary theory, Herbert Spencer, should have referred to the match as 'the greatest boon and blessing to come to

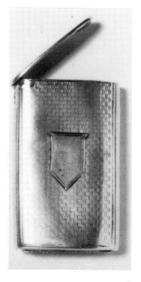

2. Silver, flap-type opening. Assayed at Birmingham in 1877 by the firm of George Unite, 1¾ × 1⅛ in.

mankind in the 19th century'.

Walker called his matches 'friction lights' but did not enter a sale in his books until April 7, 1827, when a tin box containing one hundred of the new matches was sold to a local resident, Mr. Hixon, for 1s. 2d. (*c*. 6p). The matches cost a shilling and the additional twopence was for the cylindrical tin container. Ignition was achieved by holding the match in the fold of a piece of sand-paper, which was also provided, and then drawing it out sharply so that the friction would produce the desired flame. The day-book, with the sales entry, is now housed at the Science Museum in South Kensington.

This gifted chemist does not appear to have been at all keen to capitalize on his invention; he failed to take out a patent and limited his sales mostly to customers in the North East. Inevitably imitators began to take over and the first of these was Samuel Jones, also a chemist, of The Lighthouse, 201 Strand, London. In about 1829 Jones, who had already dabbled in 'instantaneous light' devices, produced a close copy of Walker's friction lights under the more euphonic name of 'lucifers'. This venture seems to have been a commercial success and competitors soon began to appear both at home and abroad.

In France, Charles Sauria invented a match in which, for the first time, phosphorus was the main ingredient in the composition of the head. This event took place in January 1831 at Dôle in the Jura district where Sauria, aged only 19, was a student in chemistry at the Collège de l'Arc.

The Germans attribute the invention of the phosphorus match to Johann Friedrich Kammerer of Ludwigsburg, who is supposed to have achieved this while imprisoned in the Höhe Aspberg fortress. Kammerer was certainly the first German manufacturer of matches, in 1832. About the same time Roemer, Preshel and Ironiy were putting similar matches into circulation in Austria and Hungary. Many of these early matches of

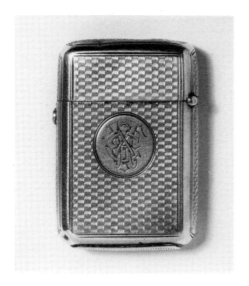

3. Silver. Springs open by sliding the stud at the front. Maker's mark not clear, hall-marked London 1869; 2 × 1⅜ in.

Continental manufacture went under the name of 'congreves', but by the late 1830s several British makers were also producing phosphoric matches.

In 1836 manufacture of phosphoric matches began in the U.S.A. when Alonzo Dwight Phillips of Springfield, Massachusetts obtained a patent for 'new and useful improvements in modes of manufacturing friction matches for instantaneous light'.

Samuel Jones was granted patent No. 6335 in 1832 for 'fuzees' intended 'to burn with a slow smouldering fire for the purpose of lighting cigars, pipes, etc.'. This match, more usually spelt fusee, also had phosphorus in its composition and thus became the first British phosphoric match.

The type of match that was going to dominate the rest of the century, however, was the vesta first made by Richard Bell in about 1833. The stems of these matches consisted of a number of cotton threads encased in wax.

This 'strike-anywhere' match managed to co-exist quite happily with the safety match, invented by the Swede Lundström in 1855. With radical changes in the composition of the head, wax matches are still popular today in Italy, Spain, Portugal and some Latin-American countries while in Britain the vesta continues in use but with a wooden stem. From the beginning, match manufacturers sold their goods in branded boxes, much as they do today, except that quite a few of the 19th century receptacles were made of metal.

The production of the small portable decorative match containers, which form the subject of this book, was started some time in the mid-19th century and appears to have reached a peak during the 1880–1914 period. In making them the craftsmen involved let their imaginations run riot regarding ornament, shape and choice of materials. They were known at first as fusee boxes or vesta boxes, but later in the century simply as matchboxes. The term vesta boxes, which I have adopted, is the one generally accepted by collectors and dealers during the last thirty years or so. In America they are known as match safes.

Some vesta boxes can fit into two or more of the categories chosen and I have therefore had to allow myself a certain amount of flexibility regarding the chapter heading under which a particular type is described.

1. Precious Metals

IT IS perhaps apt to introduce this section with an early literary reference to a box made probably of gold but certainly of nothing less than silver. It comes from *Lady Chesterfield's Letters to Her Daughters* by George Augustus Sala, whose pen painted the contemporary scene so vividly. The book was published in 1860 and in one of the letters Lady Chesterfield repeats her daughter's remarks regarding a gentleman the latter had met on a train journey:

> 'He wore a beautiful rough suit, all over pockets, and a heavy watch-guard, with two lockets – one square, one round, hanging to it. One of them perhaps, dear, held the fusees he lights his cigars with.'

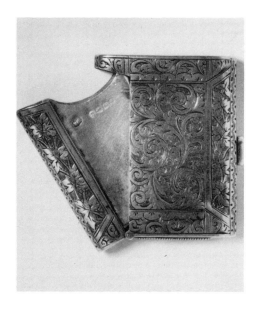

4. Silver. Maker and patentee of this form of opening was S. Basnett of Birmingham in 1887, $1^{7}/_{8} \times 1^{1}/_{2}$ in.

5. Silver oval by Walter Needham of Sheffield. Assayed at Chester in 1896, 1¾ × 1¼ in.

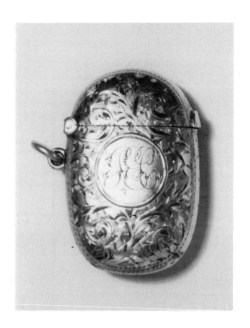

In a later paragraph she says:

> 'Your heart you say is entirely your own. Is there not a tiny portion of it in the custody of the long moustachioed gentleman with the gold locket and the fusee-box to his watch-guard?'

This chapter deals essentially with silver matchboxes, which are found in large enough quantities to satisfy the most ardent collectors. Items in 9 carat gold do turn up from time to time but are fairly rare while those of 18 carat are very scarce indeed. The majority of gold boxes are rectangular, oval or round in shape and mostly plain. One reason for the shortage is that they were very expensive in their day and comparatively few were made to supply the small number of people who could afford them. The Army and Navy Stores catalogue for 1907 advertised vesta boxes as follows:

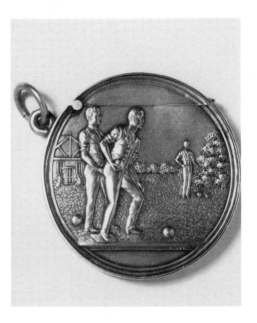

6. Silver. Intended as an award for bowls and made by Messrs. James Fenton of Birmingham in 1906, diameter 1¾ in.

'Plain silver, size 2⅛" by 1¾"
 11s. 6d. (57½p)
Without ring 11s. (55p)
Gold 9 carat 50s. (£2.50)
Gold 18 carat 120s. (£6.00)'

In addition they advertised some cheaper boxes, but also some dearer ones, depending on size. By comparison we find, in the same catalogue, that one pound of best bacon cost 1s. (5p) and a pound of roasted coffee ranged from 1s. (5p) to 2s. (10p).

Clearly the upper price range of gold vesta boxes was very high, but another reason for the shortage could be that many were melted down for their gold content during the intervening decades between being rejected as 'old fashioned' and becoming desirable pieces for collectors.

Many vesta boxes were fitted with a small

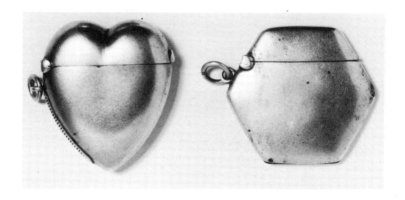

7. *(left)* Silver heart by Walter Needham of Sheffield. Assayed at Chester in 1896, 1¾ × 1⅝ in.

8. *(right)* Silver hexagon by Sanders, Mackenzie and Co. of Birmingham. Assayed at Chester in 1907.

ring for attachment to the watch-chain that spanned the Victorian and Edwardian male waistcoat. It would appear from several advertisements that an additional 6d. (2½p) was charged for a silver ring. When this was not fitted the box was simply carried in the fob and it sometimes had a concave back to fit the waist more comfortably.

The first of these receptacles resembled the smaller type of contemporary snuff box. They were rectangular and the lid was hinged on the longer side. The main difference between the two containers was the presence of a roughened striking surface on one of the narrow sides of the vesta box. The striker either formed an integral part of the box or consisted of a grooved steel plate recessed into the side so as to bring its surface flush with the body of the box. The earliest seen so far is marked with the Birmingham hallmark for 1853 and was made by the local firm of Alfred Taylor (fig. 1).

During the late 1850s a new kind of lid came into use and this was to become the dominant form until the end of the vesta box era. The lid was placed at the top of the container and hinged generally on the narrow side, although there were some exceptions when it was hinged along the width. In some the lid was flat and attached to the top edge (fig. 2), but

mostly it was hollow and fixed to the body slightly below the top (fig. 3).

There were, of course, several other forms of closure patented over the years, and these can be found occasionally. One such was made according to patent No. 1212 granted to S. Basnett on January 26, 1887. In this example a catch on the front causes an inner case to spring open sideways, revealing the matches (fig. 4).

The favourite shape was to become the rectangle with rounded corners. Oval, round, heart, and hexagonal shapes (figs. 5–8) were far less common and the novelty types representing people, animals and everyday objects, so popular in base metals, were quite rare (figs. 9, 10 and 11). The decoration was achieved by engine-turning (figs. 2 and 3), engraving (figs. 4, 5, 9 and 10), embossing (figs. 6 and 12), enamelling (fig. 13) and inlay of various ornamental stones (fig. 14). It

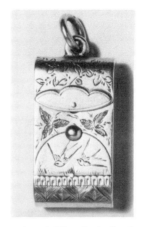

9. *(above)* Silver facsimile of a contemporary camera case. Birmingham 1881, 1⅜ × ¾ in.

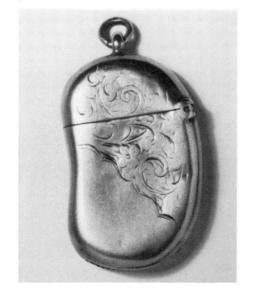

10. Silver bean-shaped vesta box made by William Hare Haseler of Birmingham in 1903, 1¾ × 1⅛ in.

11. *(above)* Sliding drawer silver vesta representing a domino. Made by James Deakin & William Deakin of Sheffield and Birmingham. Assayed at Chester in 1900, 1⅞ × 1⅛ in.

ranged from geometrical patterns to stylized flowers and foliage, buildings, humans and so on.

The flush striker of the early vesta boxes gave way to an externally applied grooved patch on most boxes with the lid at the top. In the late 1880s a new form of striker was developed, which mostly superseded the earlier types, and continued until manufacture ceased. This consisted of a suitably serrated slot, recessed at the bottom of the box, and the earliest slot-strikers seen were on items hallmarked in 1887.

Sizes were also variable, within a certain range, but occasionally one finds a box that appears to be much smaller than the norm (fig. 15) or very much larger (fig. 16).

Silver vesta boxes were sometimes presented as awards for various sports with the occasion, date and recipients' names engraved on them. The members of the winning crew in the Cambridge University Trial Eights of 1894, for instance, were apparently given one each; the Caius college shield was engraved on the obverse while on the reverse we find

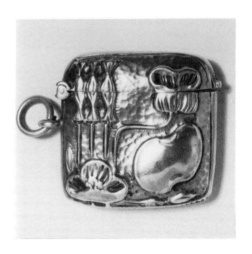

12. Embossed art nouveau design, Birmingham 1904, 1⅜ × 1½ in.

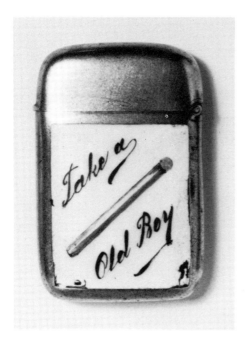

13. Enamel on silver. Made by C. H. Cheshire, Birmingham 1887. 1¾ × 1¼ in.

'C.B.C.', the title of the race, the year, and the names and weights of the eight oarsmen and the cox (fig. 17).

Early this century the Birmingham firm of James Fenton produced a series specially designed to serve as sports trophies. These were round, medal-like, with a diameter of 1¾ inches and were heavily embossed on the obverse with a scene of the sport for which they would be awarded – men playing bowls (fig. 6), golf, billiards and cricket. The reverse, which was absolutely plain, would normally be engraved with all the relevant details of the event.

Sometimes one finds an inscription indicating a personal gift on a special day or for services rendered and there is a nostalgic appeal about some of these. A box obviously once

14. *(below)* Stone inlay on silver by James Fenton, Birmingham 1901, 1½ × 1⅛ in.

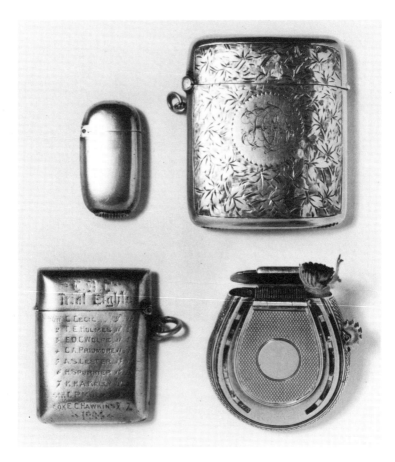

Two extremes. 15. *(above left)* Birmingham 1889, 1½ × ¾ in.
16. *(above right)* Birmingham 1910, 2½ × 2⅛ in.

17. *(below left)* Presented to members of the winning crew in the Cambridge University Trial Eights of 1894. Makers, Deakin and Francis, Birmingham 1894, 2 × 1½ in.

18. *(below right)* Vesta box with external tube for tinder cord (sometimes contemporaneously called 'Alma cord'). Made by the London firm of Thomas William Dee in 1864, 1⅞ × 1⅞ in.

19. Silver sliding drawer type of box, heavily embossed and depicting skaters on the reverse. Possibly German, late 19th century, impressed with the silver purity mark 800, 2½ × 1¾ in.

given to 'a soldier of the Queen' is inscribed:

'W. Colley
2nd. V.B.
East Surrey Regiment
South African Campaign
1900–1901'

As the years went by this must have revived many memories for the old campaigner.

A neatly engraved box is marked 'G.B.B. 1896' and is accompanied by a newspaper cutting from which it would appear that it was presented, together with a silver cigar-case, to George Barnes Bigwood, stage manager of the Britannia Theatre, Hoxton, by the owner of the establishment, Sara Lane, as a reward for his successful production of the pantomime

20. Silver with enamel decoration. Mark on inner rim consists of a crown within a crescent — a device used in Germany from 1888 for items exceeding a purity of 800. It also bears the maker's initials and the silver content figure '935', late 19th century, 1¾ × 1¾ in.

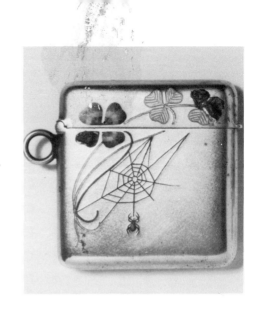

21. (below) Silver, late 19th century, Portuguese manufacture, 1⅞ × 1¼ in.

The Giant Oof Bird (*see* cover illustration).

Collectors are sometimes puzzled by a type of vesta box, occasionally shaped like a horseshoe (fig. 18), and fitted with an external tube containing a tinder rope. A small wheel, or some other form of pusher, enables the cord to slide in and out of the tube. The purpose of this, according to one patentee, is to ignite the tinder when a match is struck 'before the flame can be extinguished by wind, etc.'. The cord smoulders slowly for as long as it is required and is put out by withdrawing it into the tube and covering it with the lid provided.

Silver matchboxes made in the United Kingdom can easily be dated by means of one of the excellent little publications dealing with hallmarks, available at most bookshops. By far the greatest number of boxes appear to have been assayed at Birmingham. Comparatively few were marked at Chester and London and very few at Sheffield. Those marked elsewhere are extremely rare. The marks of origin are: an anchor for Birmingham; three

wheatsheaves and a sword (the city arms) for Chester; a leopard's head for London, and a crown for Sheffield. The marks are generally found on the inner rim of the body and inside the lid.

Silver vesta boxes made in other European countries (figs. 19–21) are much more difficult to date since many of them did not require year letters but were mostly concerned with standards of purity. They were therefore usually marked with figures such as 800, 900, 925 and so on, indicating parts of pure silver in 1000. More rarely one finds national and town marks and also those of the silversmith who made the object. Our own standard is 925 and

22. American silver vesta box. Marked 'Sterling' on inner rim and also '3325 Patent 1892', 2½ × 1⅝ in.

Three American silver vesta boxes.

23. *(left)* Typical art nouveau design. Marked 'Sterling' on inner rim, 2⅝ × 1½ in.

24. *(centre)* Marked 'Sterling', amethyst-coloured cut-glass ornament in centre, *c.* 1900, 2⅜ × 1½ in.

25. *(right)* Plain item with a family crest engraved on the back and the initials J.B. on the front. Marked 'Sterling' and the maker's name, Tiffany & Co.

this is implicit in the assay mark of a lion passant.

American silver vesta boxes were marked 'sterling' on the inner rim followed sometimes by the maker's name and more rarely the date of the patent, where applicable. A special feature of these very desirable objects, which distinguishes them from their European counterparts, was the relatively greater length compared to the width (figs. 22–25).

With the outbreak of war in 1914 and the military belt gradually replacing the watch

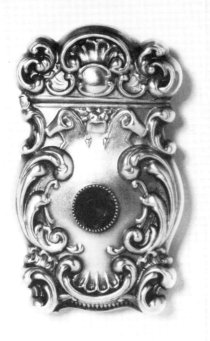
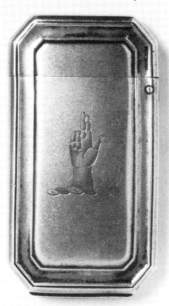

chain in many countries, the popularity of the vesta box began to wane. It lingered on into the twenties but, with the strike-anywhere match being steadily pushed into the background by the safety match, their useful life was over. The latest box noted had, in addition to the usual marks, a puncheon with the overlapping heads of King George V and Queen Mary. This mark was used from 1933 to 1935 to commemorate Their Majesties' Silver Jubilee in 1935. This, however, was probably the end of the silver matchbox era.

2. Base Metals

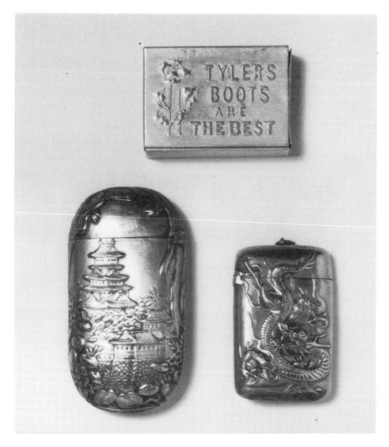

26. *(above)* Sliding-drawer aluminium advertising box, *c.* 1900, 1¾ × 1⅛ in.

27 & 28. *(below)* Typical Far Eastern work in brass, last quarter of the 19th cent. Fig 27 on left 2⅝ × 1⅜ in.

Aluminium vesta boxes were made in small numbers from about the 1890s into the 1920s. There was a reference to these in the December 16, 1893 edition of *To-Day*, a magazine published under the editorship of Jerome K. Jerome. The author of the article remarked:

'Novelties in Aluminium. I noticed in Regent Street this week a quantity of very pretty presents made of Aluminium. The prices asked for such useful articles as cigar and cigarette cases, match-boxes and ash trays is low and they are just the thing to send to country cousins where the new metal is a novelty.'

I have not myself seen an aluminium vesta that could be described as 'very pretty'. They appear to have been mostly fairly plain and sometimes used for advertising various goods (fig. 26). The main common feature of aluminium boxes is their extreme lightness by comparison with other white metals.

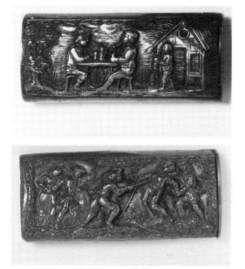

29 & 30. Heavy cast copper plaques on brass depicting (fig. 29, *above*) a convivial scene and (fig. 30, *below*) an encounter with bandits. Possibly French, last quarter of the 19th century, 2¾ × 1⅛ in.

Brass has been used extensively throughout the manufacturing countries, including the Far East (figs. 27, 28), and many of the novelty type were made of this alloy (*see* Chapter 3).

Copper was also used but not very frequently. A series of long boxes having an oval section with a hinged lid at one end and the striker at the other is distinctive. The body was made of brass but the chief feature consisted of a copper plaque, cast in high relief, applied to one side. On this was modelled convivial and sporting scenes (fig. 29), encounters with bandits (fig. 30) and other subjects. One box of this design has the French patent inscription inside the lid 'Breveté. S.G.D.G.'. They seem to belong to the third quarter of the 19th century and were probably made in France or a neighbouring country. Some show traces of silver plating.

Iron, when used, was generally tinned or japanned to prevent rusting.

31. Burnished steel with the initial 'W' decorated with small semi-precious stones. Possibly French, turn of the century, 2 × 1¾ in.

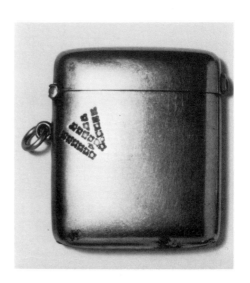

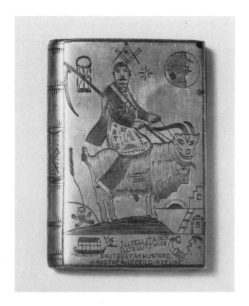

32. White metal decorated with masonic symbolism. The name 'Arthur Lindsay' is engraved on the front. English, late 19th century, 2¼ × 1⅝ in.

Pewter was not often used for vestas but the odd item shaped like a contemporary snuff box, does turn up now and again. Its purpose is made clear by the presence of a striker, in the form of grooving, at the back of the box.

Steel boxes were burnished or tempered and might sometimes have a simple decoration of precious or semi-precious stones, in the form of an initial or monogram, and a small boss at the front of the lid, used for opening it (fig. 31).

White metal vestas are legion and were made of the many stainless metal alloys that were developed during the 19th century. There were a number of silver 'look-alikes' such as Electroplated Nickel-silver, Alpaca silver, Nevada silver, German silver (actually a nickel), and many others that did not even pretend to look like silver. Many were very

33. Heavily embossed white metal vesta box, English, c. 1880s, 1¾ × 1⅝ in.

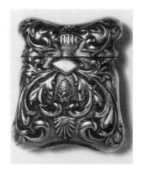

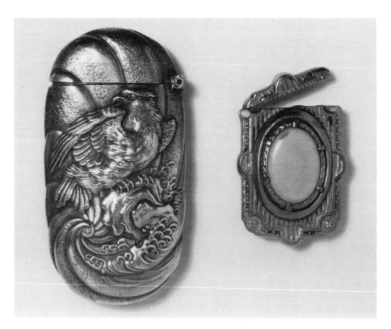

34. *(left)* A fine representation of an eagle on both sides of a white metal box, American. *c.* 1890, 2¾ × 1½ in.

35. *(right)* Pinchbeck type metal with a pottery central inset. Country of origin and date not yet established.

attractive and heavily embossed or engraved (figs. 32, 33 and 34).

Yellow metal alloys, stainless and gold-coloured, followed on from Christopher Pinchbeck's famous early 18th century invention. Vesta boxes made from these much later imitations can occasionally be found (fig. 35).

3. Metal Novelties

NOVELTY or fancy vesta boxes were, with a few exceptions, made of various metals or, sometimes, metals covered with some other material (fig. 36). They form a most diverse group and the presence of a striker is the only characteristic they have in common. Here we find depicted a whole range of living creatures from the humble molluscs through reptiles, birds and animals to humans of fact or fiction (figs. 37–42). There are examples copied from the vegetable kingdom (fig. 10) and everyday familiar objects (figs. 9, 11, 41 and 42).

The earliest novelty box referred to so far is in the form of a silver horseshoe (fig. 18) and was made in 1864 by the London silversmith Thomas William Dee. This firm, quite obvi-

36. *(above)* Box shaped like the lower part of a deer's leg, made of silver-plated brass covered in deerskin. Inside the lid is the word *Deponirt* ('Registered'). Made in Austria or Germany, turn of the century, length 3 in.

37. *(left)* Brass oyster, 2½ × 2¼ in.

ously, neither registered nor patented this item since we find a very similar design registered by Frederick Derry, a Birmingham match-box maker, in June 1871. The first British patent for a figural vesta box appears to have been taken out by two Americans – W. L. Hubbell and F. Ochs – on December 17, 1877. It was bottle-shaped and opened at the base by means of a somewhat complicated mechanism. The patentees indicated that 'the boxes may be ornamented or used for

38. Silver-plated brass, inscribed on top 'With compliments *The Plough*, Fore Street E.C.', early this century, 1¼ × 2⅝ in.

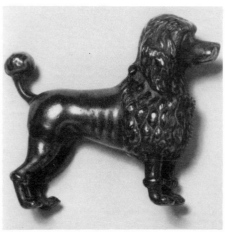

39. French poodle in brass. The head, which forms the lid, is hinged at back of neck, 1⅝ × 2 in.

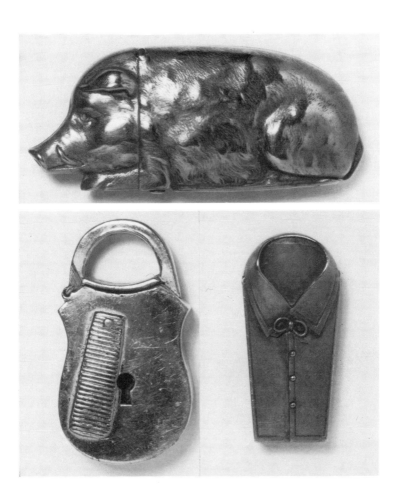

40. *(above)* Wild boar in brass. The head springs open by pressure on a stud at the base, length 3 in.

41. *(below left)* Padlock in white metal, late 19th century, 2⅛ × 1¼ in.

42. *(below right)* Brass vesta box in the shape of a shirt; the bow-tie is made of copper and can be moved slightly. It has oriental style engraving on the back and was probably made in Japan, 1¾ × ⅞ in.

advertising purposes'. These were probably manufactured and distributed in the U.S.A.

Vesta boxes in the shape of bottles but of a simpler design, appear to have been made in Austria during the late 19th and early 20th centuries. These looked like miniature champagne or ale bottles, opened by a simple hinge at the neck and advertised French champagnes or British beers (fig. 76).

In February 1884, E. H. Cashmore and F. W. Mole, die sinkers, tool makers, stampers and piercers of 104 Vyse Street, Birmingham, patented a matchbox

'made to represent the leg of a football

43. W. E. Gladstone, the Liberal leader and Prime Minister. Two different busts made of silver-plated brass, possibly on his death in 1898. Heights 2⅛ and 1¾ in. respectively.

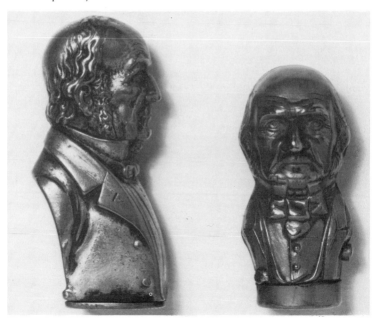

player, cut off above the knee with a pad strapped to the leg and the ball resting on the foot – the football forming a separate receptacle or box to contain snuff, scent or other substance, can be provided with a suitable hinged, pivoted or sliding lid. The matches contained in the leg-shaped box can be struck on a roughened surface provided for that purpose on the sole of the foot or they can be struck on the rough pad or legging.'

These little containers were still very much with us at the end of the century. They take up a full page in the trade catalogue issued by Messrs. Salmon & Gluckstein, tobacco manufacturers and tobacconists, in 1899. In this they are referred to as 'Fancy Vesta Boxes', and range in price from 3d. to 7½d. per box. Among the items included are a small dog emerging from a top-hat, at the higher price, a skull and a pig at 3½d., and several others.

Only a comparatively small number of novelty vestas was covered by registration of design or by patents and this makes research into their date and place of manufacture much more difficult. They appear to originate mostly from Europe and to a much lesser extent from Japan. A few were made in the United States and the most notable of these consists of a series representing the profiles of various presidents.

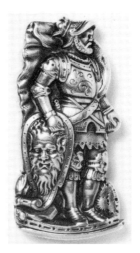

44. Legendary German hero in white metal, inscribed Köln (Cologne) in gothic letters on the back. Made in Germany in the last quarter of the 19th century, height 2¼ in.

4. Miscellaneous Materials

45. Vesta box made from an Australian bean with silver fittings, Birmingham hallmark for 1884, 2 × 1⅝ in.

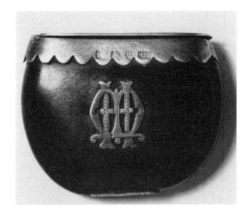

46. Another Australian bean vesta box, this one with silver-plated fittings, 1⅞ × 1⅝ in.

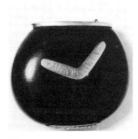

Bean. Professor E. E. Morris, in his *Australian–English Dictionary of Australasian Words*, published in 1898, has the following entry:

'Match-box bean – the hard seed of the Queensland tree *(Entada scandens)* of which match-boxes are made.'

The flowers of this tree produce enormous pods containing the large dark-brown seeds used in this instance. After drying, a slice was cut from the bean so that the inside could be scooped out to form a container. A silver or silver-plated lid was then fitted at the opening and a striker in the form of a grooved piece of metal was placed at the bottom. Sometimes a silver shield for initials, or a monogram, was added (fig. 45).

Some of these seeds were imported and converted into vesta boxes in this country. This is apparent from the English hallmarks and inscriptions on the lids. The earliest date seen is 1884. Many, of course, must have been made in their country of origin, such as an item with

a distinctly Australian flavour. On this a silver boomerang with the word 'Australia' engraved on it has been fitted to the bean (fig. 46).

Celluloid, being chemically produced, was the earliest form of plastic, as the term is now generally understood. It was invented in the United States by John Wesley Hyatt in 1869 but as late as 1881 the author of an article in *Cassell's Family Magazine* described it as 'this new material'. He goes on to say that it is becoming largely used for ornamental and decorative purposes and that:

> 'It can be made, by proper pigments, to imitate very closely such diverse substances as amber, jade, shell, ebony, tortoiseshell, etc.; and it can be moulded into any required shape.'

Celluloid was used in the manufacture of

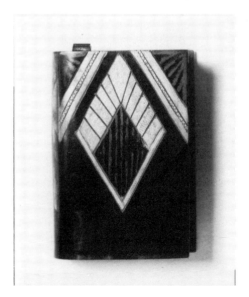

47. Celluloid, ornamented in the art deco style, early 1930s, 2⅛ × 1½ in.

48. *(above)* Imitation sealskin vesta box, English 1880s, 3 × 1¾ in.

some vesta boxes and so were other later plastics. Determining the actual composition used belongs to the realms of analytical chemistry. It is enough for the collector to know the difference between the natural substance and a plastic imitation but this skill can only be acquired with experience. A tortoiseshell imitation in celluloid is found in a few fairly plain vesta boxes towards the end of their period. One of these has a typical art deco embellishment, in gilt, of the late 1920s to the early 1930s (fig. 47).

Fur is a rather unexpected material but vestas made of this substance do exist. The fur used was often imitation sealskin. The description of a cigar case in the 1885 *Catalogue of British and Foreign Goods*, issued by the London warehouse of A. M. Silber, applies also to vesta boxes since these were intended to match

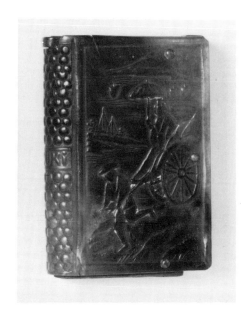

49. Moulded from horn, Japanese, 1920s, 2½ × 1¾ in.

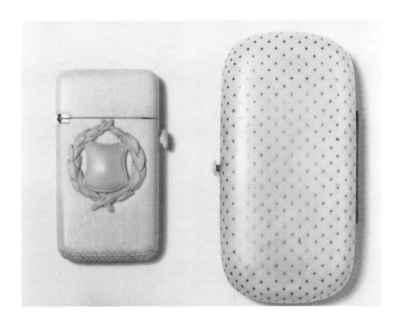

the large receptacle: 'Imitation sealskin cigar case, nickel-silver frame, lined with silk or satin.'

These containers were fitted with a hinge and opened by pressure on some form of stud at the front. Both halves were provided with a small pocket to hold the matches and an internal glass-paper striker (fig. 48).

Horn, heat pressed and moulded to give a raised decoration, is not common in vesta boxes but examples from various countries are known. One from Japan is in the form of a book and opens by means of a flap at the top. The striker is at the bottom. The decorative motifs, including a rickshaw-boy in action, are Japanese. The word 'Suzuki' in relief appears on the spine indicating, possibly, a publicity gift from the famous firm, established in 1920 (fig. 49).

50. *(left)* Ivory, springs open by pressure on a stud at the front, 2⅛ × 1¼ in.

51. *(right)* Ivory, longitudinally hinged and opening like a purse. Continental manufacture, 3 × 1½ in.

52. Ivory plaques attached back and front to a metal-framed leather purse. It has internal pockets for the matches and a sandpaper striker, last quarter of the 19th century, 2½ × 1⅞ in.

53. *(below)* Ivory novelty in the form of a wooden crate. Made in France in the late 19th century, 1⅞ × 1⅛ in.

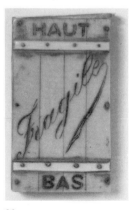

Ivory boxes were generally popular during the second half of the 19th century. Some were made in the conventional shape of the contemporary silver vesta (fig. 50); others were like a small purse, longitudinally hinged and opened by pressure on a stud at the front (fig. 51). In yet others a plain or carved ivory plaque was attached to the back and front of a purse-like leather vesta (fig. 52). One of the rare non-metallic novelties takes the form of a wooden crate and was made in France. The word *Fragile*, which has the same meaning as in English, was printed on the crate and also *Haut* and *Bas* ('top' and 'bottom') (fig. 53).

Leather receptacles often matched cigar-cases in shape and were made of various hides as well as crocodile skin. In the 1885 catalogue

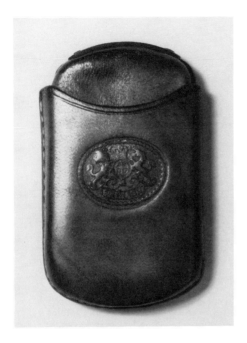

54. Leather pull-out type. The striker, in the form of a piece of grooved iron, is fitted at the top. Made in England during the 1880s, 2⅜ × 1½ in.

referred to under 'Fur' there are two relevant entries:

1. Solid leather pull-out Fusee case, with embossed Royal Arms (fig. 54).
2. Real pig-skin pull-out Fusee case with striker at top.

The grooved iron strikers were generally attached to the top. Sometimes we find a strengthening silver band round the rim of the container such as in the crocodile skin example illustrated (fig. 55).

Mother-of-Pearl is usually seen in the form of plaques decorating vesta boxes made of some other material (fig. 56), but boxes entirely covered by this beautiful natural substance are rare and most attractive. These were

55. *(below)* Crocodile skin with silver fitting bearing the London hallmark for 1898, 2⅜ × 1¾ in.

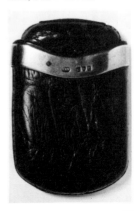

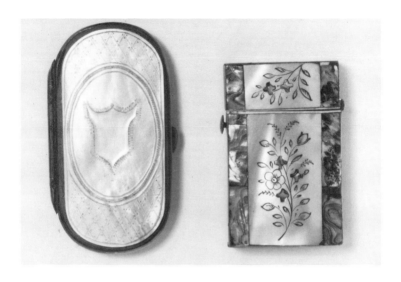

56. *(left)* Mother-of-pearl plaques attached to a metal-framed leather purse. Other details similar to fig. 52, 2½ × 1⅜ in.

57. *(right)* Mother-of-pearl vesta box combining nacre from a species of oyster and that obtained from an iridescent haliotid (Abalone). English, third quarter of the 19th century, 2 × 1¼ in.

mostly made during the third quarter of the 19th century and were simply miniatures of the popular card and cigar cases of the period. Here we find a combination of various colours of pearl, often engraved, covering a wooden core in a most effective manner (fig. 57).

Papier mâché, although invented in the 18th century, is regarded as a typical product of the Victorian era. Surprisingly, one only finds book-shaped vesta boxes in this material. They are decorated in a type of chinoiserie popular in the late 19th century (fig. 58).

Stone. Collectors will have noticed vesta boxes in which a polished stone is fitted, top and bottom, to a central band of metal. The stone most commonly used is artificially stained agate, but onyx, moss agate and carnelian are also found. The metal is sometimes inscribed with the name of the owner and the date when it was given to him or her. Dates noted so far are between 1870 and 1891 but the

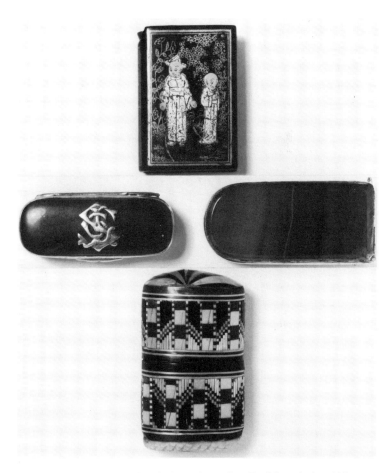

58. *(above)* Papier mâché with chinoiserie decoration, English made, late 19th century.
59. *(centre left)* Blue-stained agate in a silver setting. No silver mark; box inscribed 'NELIE WELT JULY 16th 1870'.
60. *(centre right)* Cornelian in a setting of Pinchbeck-like metal, inscribed 'Arthur Neale, 11th July, 1891', length 2½ in.; striker inside flap-lid.
61. *(below)* Straw mosaic work on a cardboard core, made in Spain early this century.

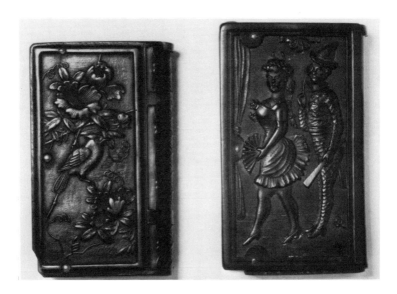

62a & b *(above)* Moulded vulcanite, made in Germany, late 19th century.
63. *(below)* Red vulcanite made for the French market. Marked 'Made in Germany', early 20th century.

country of origin has not yet been identified (figs 59 and 60).

Straw mosaic work in colour, on a core of thick card, was a Spanish speciality and some vesta boxes were also made in this medium. They were in the form of small étuis and the striker, made of bone suitably serrated, was placed at the bottom of the container. The designs varied from region to region (fig. 61).

Vulcanite is a natural rubber hardened by a somewhat involved chemical process. A large number of book-shaped vestas, with dic-stamped ornament, were made of it. They opened by means of a flap at the top and often had flaps at both top and bottom. Black vulcanite was extensively used but browns, reds and olive-green are also found. These boxes were made in Germany and covered a big range of subjects, including commemoratives,

which will be more fully dealt with in Chapter 6 (figs. 62a and 62b). Some, made for the French market, had the word *Feu* (literally 'fire' but used in its meaning of 'light') on the front and sometimes 'Made in Germany' on the back (fig. 63).

Another series, probably made by the firm of Charles Mackintosh of London and Manchester, were either book or horseshoe shaped. These were plain but had a glazed frame fitted at the front with photographs of royalty, Boer War personalities, buildings, views and private people (figs. 64 and 65).

Wood has been used extensively for the manufacture of souvenir type vesta boxes. They are found in the sycamore ware manufactured mostly in Scotland and particularly by the firm of William and Andrew Smith at Mauchline in Ayrshire. These were decorated with transfer-printed engravings showing

64. *(left)* Vulcanite vesta box with glazed photograph of General Sir George White, V.C., the Boer War hero. Made in England about 1901/2, 2 × 1½ in.

65. *(right)* Vulcanite, with glazed photograph of an unidentified lady. Made in England, early 20th century.

66. Sycamore wood souvenir of the Burns Cottage. On the back:
'BOUGHT IN THE COTTAGE
The gossip keekit in his loof etc.'
Made in Scotland, possibly Ayrshire, during the third quarter of the 19th century, 1¾ × 1⅜ in.

views of resorts and tourist spots and were made mainly during the second half of the 19th century (fig. 66). There are carved boxes from the forest regions of central Europe in various woods (fig. 67) and black bogwood from Ireland decorated with Irish symbolism such as shamrocks, harps, wolfhounds, and so on (fig. 68). There is inlay work from Sorrento (fig. 69) and olive wood vestas from various areas, including Jerusalem, in the Mediterranean basin. An unusual item opening like a roll-top desk is illustrated (fig. 70); a similar specimen was seen as one of the fittings in a smoker's compendium dated January 3, 1879.

Vesta Cases in other materials such as **Glass** (fig. 71) and **Tortoiseshell** are occasionally found but they are too rare to merit detailed descriptions.

Enamel has not been mentioned in the alphabetical listing of materials because it

67. Carved wood with sliding lid, stamped inside 'Grand Bazar, Schlaseter, Lucerne', Switzerland, last quarter of the 19th century, 2¾ × 1½ in.

68. Bogwood souvenir from Ireland, late 19th century, 2 × 1½ in.

69. Olive wood with Sorrento inlay decoration, Italy, last quarter of the 19th century, 2½ × 1⅜ in.

was not actually used for making vesta boxes. It was in fact a very attractive decorative feature applied to metal boxes. An interesting series made in France from about the 1880s had a painted enamel plaque on the lid of a small gilt brass box. More rarely there was a matching plaque on the reverse, and because of the scantily clad ladies often portrayed, these vestas were considered risqué in their day (*see* cover illustration).

The London firm of Sampson Mordan, specialists in small silver items, produced a number of vesta boxes whose lids were decorated with sporting and other scenes painted on enamel. There were, of course, many other firms specialising in enamel embellishments at home and abroad (fig. 72). A series of souvenir type white metal vesta boxes exists in which the enamel arms of a town, shipping line or other institution has been added at the front (figs. 73 and 74).

70. Wooden vesta box with roll-top opening, *c.* 1880s; 2¼ × 1½ in.

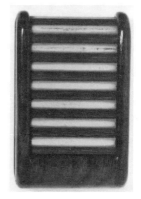

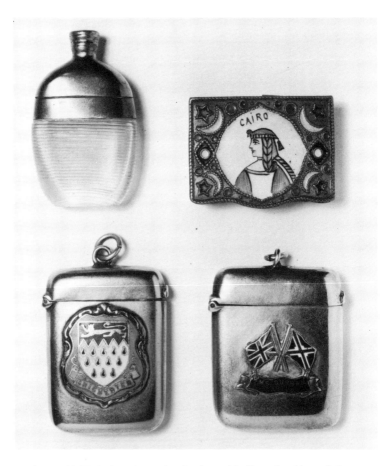

71. *(above left)* Flask-shaped vesta box in glass, with silver-plated brass fitting at the top, late 19th century, height 2¼ in.
72. *(above right)* Gilt brass box with enamel decoration. Souvenir from Cairo, made in Egypt, *c.* 1890s.
73. *(below left)* Electroplated nickel-silver, decorated with the arms of Chichester in enamel, early 20th century.
74. *(below right)* Electroplated nickel-silver souvenir of the Royal Mail steamer *Durham Castle* with crossed flags in enamel (Union Jack and Union Castle Line), early 20th century.

5. Advertising

DURING the latter years of the nineteenth century the use of matches had become almost universal, thereby making it natural that the containers should be exploited as a means of advertising. In this respect they were forerunners of the printed covers on book matches and the labels on matchboxes of today.

Some of the shapes reflected the goods advertised and brought them into the 'novelty' class described earlier (figs. 75 and 76). Others were more conventional in design and carried advertising embossed or impressed on the box itself or printed on a piece of celluloid attached to the box (figs. 77 and 78).

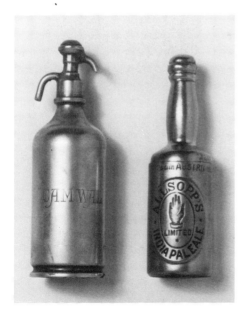

75. *(left)* White metal, advertising the Chemists' Aerated Mineral Water Association Ltd; hence the inscription 'Camwal'. Based on design 243021, registered by their manager F. G. Pirie on October 25, 1894; height 2½ in.

76. *(right)* Silver-plated on brass, advertising Allsopp's India Pale Ale, made in Austria, late 19th century.

77. White metal advertising a Rye watchmaker. Inscribed on the reverse '1837 V.R. 1901', commemorating the death of Queen Victoria; 1⅞ × 1⅜ in.

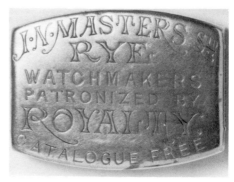

78. White metal with celluloid centre advertising Reid's Stout. An internal container swings out by pressure on the centre, late 19th century; 1⅞ × 1¼ in.

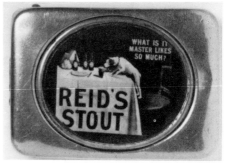

Another category consists of small tins containing a sample of the product advertised and with a corrugated striker on the reverse. Once the sample product had been used the boxes could be filled with matches and their advertising value continued as long as they remained in use. In this category we find tins originally containing tobacco, razor blades, gramophone needles, pens and small samples of tea and cocoa (figs. 79 and 80). There may well be others. Among the advertisements one finds a few firms that are still going strong, while many, once household names, are now nostalgically defunct.

A distinctive group of rectangular boxes with rounded corners is found in two sizes of

about 2¼ in. by 1½ in. and 2¾ in. by 1½ in. The body of the box is made of tinned iron while the ends are nickel-plated brass. One end consists of the hinged lid while the other end is fixed and matches the lid. A celluloid wrapper round the body carried the desired information and was further decorated by one of various processes such as photography, lithography or some other form of engraving (figs. 81 and 82).

Printed information on the narrow sides of the wrapper is most useful in determining the origins and dates of this group. Quite a number are inscribed 'The Whitehead & Hoag Co. 92 Fleet Street, London E.C., Made in U.S.A.' The date of issue of their boxes can be narrowed down by the fact that they only used this address between 1904 and 1909. They were entered in the London directories as 'Advertising Novelty Makers'. This firm's American connection is further illustrated on an advertising box made for The Globe Timber Mills of Australia on which the address of Whitehead & Hoag is given as Newark, New Jersey.

Two boxes in my own collection have 'Ajax Ltd. Philpot Lane, London. Made in U.S.A.' printed on one of the sides. The directories

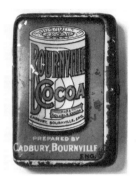

79. Brass covered iron box containing a sample of Bournville Cocoa with instructions inside for making 'One large Breakfast Cup'. The base has a grooved patch to act as a striker for matches, *c.* 1920s.

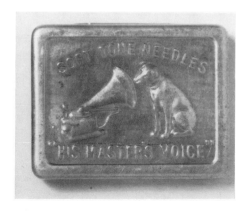

80. Aluminium box for gramophone needles. A grooved patch on the base forms the striker for eventual use as a vesta box, *c.* 1920s; 1¾ × 1⅜ in.

81. Tinned iron with nickel-plated brass ends and celluloid wrapper. On reverse 'Compliments of Peat Moss Litter Supply Co. Ltd., 36 Mark Lane, London E.C.' Made in the U.S.A., c. 1905; 2¾ × 1½ in.

82. *(below)* Make up as in fig. 81 and on reverse, 'With compliments of Tasker, Sons & Co. Ltd. India Rubber and Leather Works, Angel Street, Sheffield, England', made in the U.S.A. and handled in London by Ajax Printing Co. Ltd., 1906/1908; 2¼ × 1½ in.

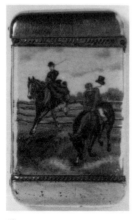

show that Ajax Printing Co. Ltd. operated at No. 16 Philpot Lane for two years only (1906–1908) (fig. 82). It is reasonable to assume that they imported the boxes from the States and printed the wrappers themselves.

The earliest of this type of vesta box seen must have been made in 1902 for distribution at the end of the year. It is inscribed 'All Good Luck in 1903, Abdulla & Co. Ltd. Cigarette Specialists.' There is no mention of a London distributor and the sides are blank except for the words 'Made in U.S.A.' From the investigation of some 30 of these receptacles it became apparent that they were made during the first decade of this century, but the possibility of an extension of a year or two either way cannot be totally excluded.

6. Commemoratives

VESTA boxes commemorating people and events were made in sufficient numbers to form the subject of a thematic collection for anyone interested in history. Royalty were the favourite subjects, closely followed by statesmen and military leaders. Souvenirs of the many international exhibitions held in Europe and the United States during the period of the vesta's popularity also proliferated.

A silver-plated box, engraved with the royal arms and 'Victoria Jubilee 1837–1887', was issued by an unidentified maker to celebrate the Queen's Golden Jubilee (fig. 83). From the

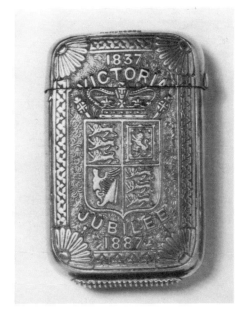

83. White metal vesta box commemorating Queen Victoria's Golden Jubilee in 1887, 2⅛ × 1⅜ in.

84. *(above)* Silver box made by the Birmingham firm of Joseph Gloster in 1896 for the 1897 celebrations of the Queen's Diamond Jubilee, 2 × 1½ in.

numerous boxes produced for her Diamond Jubilee, the illustration shows a silver box by the Birmingham firm of Joseph Gloster, hallmarked in 1896 and ready in good time for the festivities of 1897 (fig. 84). Her death in 1901 was much lamented and one design to mark the occasion was a black vulcanite vesta box with Her Majesty's profile and the words *In Memoriam* underneath. On the reverse one finds the royal monogram engraved and also the rose, thistle and shamrock symbolizing the United Kingdom. This was made by the German firm already mentioned in Chapter 4 under Vulcanite (fig. 85). A companion box commemorating the accession of the new sovereign, Edward VII, was made at the same time. A silver-plated item, in the popular book shape, has the bust of Edward wearing the

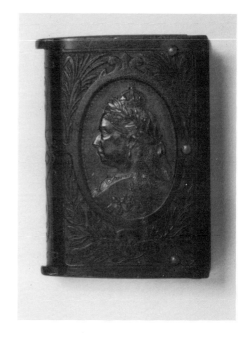

85. Vulcanite. Made in Germany for the British market on the occasion of Queen Victoria's death in 1901, 2 × 1½ in.

crown on the obverse and the royal cypher with 'Long Live The King' on the reverse. This celebrated the Coronation of 1902 (fig. 86).

A German commemorative in vulcanite in the shape of a long book has on the front cover the bearded head of Frederick III who, in 1888, became Emperor of Germany. On the back cover is the head of William I, King of Prussia, and from 1871 Emperor of Germany. On the spine, within the iron cross, is the letter 'W' surmounted by a crown and the date 1871 underneath. It is not clear whether this box was made in that year, to commemorate the creation of the German Empire, or whether the 1871 is merely symbolic and the box made in 1888 when Frederick succeeded William. More research is required on this point. In

86. *(above)* White metal, commemorating the Coronation of King Edward VII in 1902. On the obverse: 'Long Live The King' and the royal cypher in the centre, 1¾ × 1⅜ in.

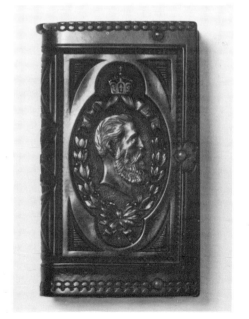

87. Vulcanite, Emperor Frederick III of Germany. Made in Germany (*see* text for details), 2½ × 1½ in.

88. *(above)* Nickel-silver. On reverse
 'Ralph Slazenger
 1909–1910
 Sheriff of London'

either case this is still the earliest vulcanite vesta box seen (fig. 87). The latest dateable box in this medium was made for the Coronation of King George V and Queen Mary in 1911 and shows their profiles on the front and St. George slaying the dragon on the back.

Civic worthies were not often featured but the odd one can be found. A nickel-silver box has on the front a framed coloured photograph, protected by celluloid, representing a fine looking elderly gentleman in his robes of office and embossed on the back 'RALPH SLAZENGER SHERIFF OF LONDON – 1909–10'. This was probably made for distribution to colleagues to celebrate the year in which he held this high office (fig. 88).

The four hundredth anniversary of the discovery of the New World by Columbus was celebrated with the Columbian Fair held in

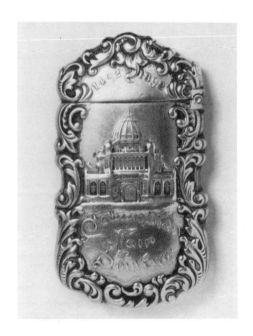

89. White metal, made in the U.S.A. as a souvenir of the Columbian Fair held at Chicago in 1892, 2½ × 1½ in.

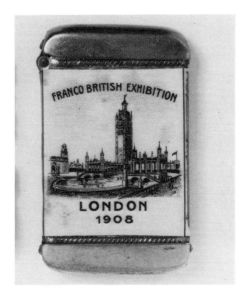

90. Souvenir of the Franco-British Exhibition held in London in 1908. On the reverse the crossed flags of the two participating nations. Box made in the U.S.A. and the celluloid wrapper printed in the Rhineland, $2\frac{1}{4} \times 1\frac{1}{2}$ in.

Chicago in 1892. On this occasion several souvenir vesta boxes were made including the design illustrated (fig. 89). A box similar in every way to the American-made advertising boxes described in the previous chapter was issued for the Franco-British Exhibition held in London in 1908 (fig. 90). The main difference was the inscription on the narrow side which in this instance is 'C.E.B. & Co. Regd. No. 430409 Printed in Rhineland'. According to the relevant records 430409 relates to a design registered by 'Charles E. Brann & Co. Fancy goods merchants 34/35 Grays Inn Rd. W.C.' on April 13 1904. It would seem that they registered the idea of a wrapper with views of resorts and their arms, souvenirs of events, and so on to be placed on metal matchboxes. It is quite likely that this firm imported the boxes from America, had the wrappers printed in the Rhineland and put them together in this country. The date of registration

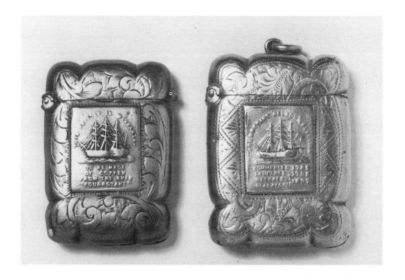

91a Copper and 91b silver-plated copper, made in 1897 (*see* text for details)

is not necessarily the date of manufacture which can continue as long as the registrant requires it.

A different type of souvenir is illustrated by a copper vesta with a sailing ship embossed on it and the words 'This article is warranted to be made of copper from the ship *Foudroyant*' (fig. 91a). A somewhat similar box but silver-plated on copper gives an explanation of the occasion:

'Foudroyant. Nelson's Flagship.
Commenced 1789
Launched 1798
Wrecked Blackpool 1897' (fig. 91b).

When the ship was wrecked by a storm a number of small souvenirs, including vesta boxes, were made from the recovered copper and suitably inscribed.

A silver vesta box sliding open like a drawer was made in 1926 by the Goldsmiths and Silversmiths Company of 112 Regent Street. Engraved on it is the once famous heading,

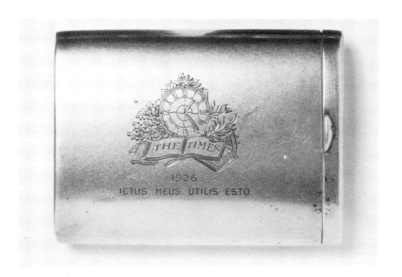

recently replaced, of *The Times* newspaper and consisting of a clock and foliage above the words 'THE TIMES'. Under the device is engraved the year 1926 and the Latin motto *Ictus meus utilis esto* which freely translated means 'May my endeavour have been of use'. The time shown on the clock is 1.24 instead of the usual 4.30 of recent years (fig. 92).

This memento of the General Strike of 1926 was presented at the end of the emergency by Major Astor, the then proprietor, to all members of staff, pensioners and outside volunteers who rallied round in order to keep up production. The 1.24 a.m. refers to the time the very first copy of May 5 was issued.*

92. Silver, 1926 (*see* text for details) 2⅜ × 1¾ in.

* I am indebted for some of the above information to Mr. Gordon Philips, *The Times* Archivist and researcher in 1978.

7. Combination Boxes

THE majority of vesta boxes were intended for matches only but a number were designed to incorporate receptacles or items used for other purposes. An early reference to one of these appears in Fairholt's *Tobacco, its History and Associations*, published in 1859. Speaking of a pocket-knife designed as a cigar-cutter made in Berlin 'some years ago', he goes on to say:

'On one side of the handle was a thin flat box, with a division; the longer one contained fusees, the smaller German tinder;

93. *(left)* Combination vesta box and cigar-cutter, of metal, with mother-of-pearl panels. The lid springs open by pressure on the knob at the top, third quarter 19th century.
94. *(right)* Combined white metal vesta box and whistle, made in Germany, *c.* 1880s, length 2⅝ in.

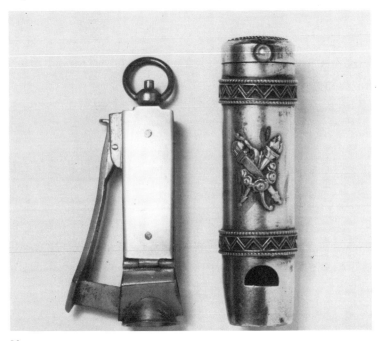

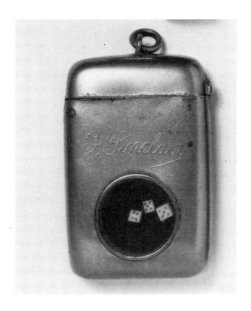

95. White metal box with unidentified game requiring three dice, 2 × 1⅜ in.

the fusee was lighted by rubbing along the rough edge of the lower part of the shallow box.'

The combination of match-box and cigar cutter is fairly obvious and many variants exist (fig. 93). Not so immediately obvious are others such as vesta box and whistle, for instance (fig. 94), or a vesta box with three dice held in a glazed compartment (fig. 95).

Book-shaped boxes, intended for vestas and stamps and usually made of white metal with various embellishments, are fairly common. The covers open by means of a strong spring hinge to reveal the match compartment at the top and that for stamps at the bottom. They were based on a design registered on February 24, 1902, by the firm of C. E. Brann & Co. mentioned in Chapter 6 (fig. 96). A design differing from these in only one respect was registered shortly before the outbreak of the First World War. Here the stamp receptacle had

96. *(below)* Nickel-plated container for vestas and stamps based on a design registered in 1902. Decorated with the crest of the Isle of Man, 1⅞ × 1⅜ in.

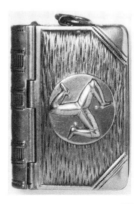

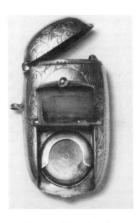

97. *(above)* Chased electroplated combination box with compartments for vestas, sovereigns, stamps and two tubes in the vesta compartment for a pencil and toothpick. Patent 4709 of 1887.

been replaced by a spring-loaded piston to hold a few sovereigns, a sad reminder of the gold coin days that were to end so soon after.

A more elaborate container was advertised in *Answers* of January 4, 1890:

A useful present for a Gentleman
 THE ALBERT
COMBINATION MATCHBOX
 (Patent)
Is constructed in the most substantial and beautifully finished manner in both STERLING SILVER and ELECTRO-PLATE. Each box is fitted with a PENCIL and TOOTHPICK, and contains compartments for VESTAS, POSTAGE STAMPS and SOVEREIGNS. IT is the most compact thing out, in exact size of sketch (2½ by 1½ by 1½ inches) and may be attached to watch chain and carried comfortably in the waistcoat pocket.

PRICES:- ELECTRO-PLATED,
 Plain 5s. 6d., (27½p)

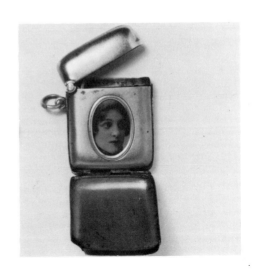

98. Described in its day as the 'Secret Photo Matchbox': a false side can be opened to reveal the hidden photograph. Silver, made by Deakin & Francis of Birmingham, 1907.

Chased 7s. (35p)
STERLING SILVER (Hall-marked)
Plain 35s. (£1.75)
Post Free
Cash returned if not approved.
J. N. Masters, Jeweller, Rye Sussex.'

The original patent for this box was granted to F. W. Powell on March 29, 1887 and numbered 4709. According to the Patent Office specification it also had 'a receptacle for a cigar cutter', yet not one of many such items seen was provided with this fitting (fig. 97).

The 'Secret Photo Match-Box' was advertised in *The Sketch* of November 21, 1894 by Messrs. Wilson and Gill of Regent Street, London. A later box of this type is illustrated (fig. 98). There are vesta boxes combined with various other objects such as compasses and even one made from vulcanite with a railway ticket slot. Some might have a pencil attached, others a button hook (figs. 99 and 100) and the reader might have fun finding other fittings not mentioned here.

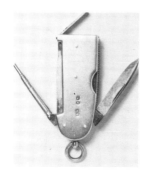

99. *(above)* Silver combination vesta box with pen-knife and propelling pencil, made by the firm of Sampson Mordan of London in 1888, 2 × ¾ in.

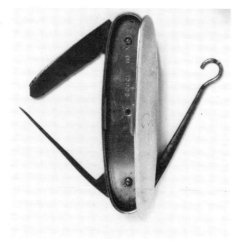

100. Silver combination vesta box with pen-knife, button hook and a smoker's spike, London, 1882, length 2¾ in.

8. Hints on Collecting

THE sources of vesta boxes are many and range from antique and second-hand shops to junk shops, market stalls, auctions and, if lucky, the occasional gift from a relative or friend. It was just such a gift of three boxes from an old aunt, some thirty years ago, that triggered off my desire to collect and research these unpretentious but very personal little artefacts. They illustrate in a small way the social history and artistic inclinations of generations now long departed and take us back nostalgically to a much more tranquil way of life which began to end with the outbreak of the First World War in 1914 and was totally extinguished when the Second World War started in 1939.

What to pay? As much as you can easily afford depending on the desirability, to you, of the item. Prices, unlike those of some mass-produced collectables such as stamps, postcards and pot-lids cannot in any way be catalogued. Most models were made in small numbers and the price now would depend on how much a dealer has had to pay for it in the first place and how much time and petrol he has used in hunting it down. His overheads must also be considered: the rent, heating and so on per unit in one of the smart antique centres is very much higher than that of a market stall. The many variables that make an item more desirable must also be considered.

In the case of a silver vesta box, for instance, we have condition, age, artistic merit of the engraving, additional decoration in the form of minerals or enamel, rarity of shape and assay office, status of the silversmith involved and importance of inscription, if any. Bearing all this in mind prices mentioned here, based on some seen recently (October 1982), must be regarded as an extremely rough guide:

Silver vesta boxes: £15–£26.

The same with an Edinburgh or Dublin hallmark: £32+

The same with simple enamel decoration: £30–£35

Full enamel decoration on long boxes by Sampson Mordan & Co. from £140.

N.B. All the above can cost very much less, and give just as much pleasure to the collector, if slightly imperfect. This, however, is a matter of individual choice.

Silver-plated or other white metal vesta boxes, attractively engraved or embossed, can still be found at between £3 and £6. Novelties cost from £12 in base metals and from £35 in silver. Vulcanite, advertising and souvenir boxes are usually between £3 and £12.

Here, as in every other collecting field, the faker has been at work in recent years, producing what are euphemistically referred to as reproductions. Unfortunately some non-specialist dealers have been deceived by these worthless fakes and sold them in all innocence believing them to be genuine. I say 'worthless' because their essential charm, from the collector's point of view, lies in the fact that they were a spontaneous product of their day, made for a specific purpose and linked to a certain fashion.

One piece of trickery consists in attaching a cheap enamel badge, in the form of a bird, animal or similar motif to an old but plain silver vesta box. An inflated price is asked for these 'enamel on silver' items which are now no more than a ruined plain but honest old vesta. More difficult to detect are those where plain old boxes have been artistically enamelled, mostly with the heads of various dogs. The skill of the work is undeniable but since the prices asked for them are prohibitive they do not pose too serious a threat to the collector.

Fortunately, apart from the above, only the novelty type, in both silver and base metals, has been affected. Some silver items such as a pig, Punch and others were made in this country and hallmarked in 1977; others, including

a combination vesta box and whistle, animals' heads and so on were made abroad, possibly in Italy. These were impressed with the import mark and assayed during the 1970s. All the above can be avoided by checking the hallmark carefully before purchase.

There are also the out-and-out fakes where vestas have been cast using moulds taken from the original stamped-out item, including its hallmarks; or even new designs created with simulated silver marks. The marks on these castings are somewhat unclear but even so their detection requires a certain amount of expertise.

The distinguishing feature of base metal fakes is the total lack of wear on the striker even where an appearance of wear has been artificially given to the receptacle. Very few of the original base metal vesta boxes were cast, while most of the fakes are. The originals were usually shaped from sheet metal.

To the best of my knowledge all other categories are untainted, and since the percentage of spurious vesta boxes is minimal collectors should not worry unduly but simply take care, bearing in mind the possibilities outlined in this chapter.

Books for Further Reading

Banister, Judith *English Silver Hall-Marks*, Foulsham & Co. Ltd., London.
Bradbury, Frederick *Guide to Marks of Origin on British and Irish Silver*, J. W. Northend, West Street, Sheffield.
Christy, Miller *The Bryant and May Museum of Fire-Making Appliances – Catalogue of the Exhibits*, Simpkin, Marshall, Hamilton, Kent & Co. Ltd., 1926; Supplement 1928.
Fresco-Corbu, Roger 'Fancy Vesta Boxes' *Art and Antiques Weekly*, August 5, 1972.
Fresco-Corbu, Roger 'Silver Vesta Boxes' *Art and Antiques Weekly*, October 8, 1977.
Sullivan, Audrey G. *A History of Match Safes in the United States*, Riverside Press, Inc., Fort Lauderdale, Florida, U.S.A., 1978.
Thomas, Doreen *Strike a Light – John Walker 1781–1859*, Teesside Museum Service, 1971.

Index

Bold page numbers refer to illustrations

Advertising, **22**, 23, 28, 30, **45–48**, 61
Ajax Ltd., 47, **48**
Alma cord, **16**
Aluminium, **22**, 23, **47**
America, 7, **19**, 20, **26**, 30, 31, 33, 47, **48**, **52**, **53**
Army & Navy Stores, 10
Art Deco, **33**, 34
Art Nouveau, **14**, **20**
Australian bean, **32**
Austria, 6, **27**, 30, **45**

Basnett, S. **9**, 13
Bean (*see* Australian bean)
Bell, Richard, 7
Birmingham, **4**, **5**, **9**, **11–16**, 18, 30, **32**, **50**, 58
Brass, **22**, 23, 24, **27–30**, 43, **44**, **45**, 47, 48

Cashmore, E. H. 30
Celluloid, 33, 34, **45–48**, 52, **53**
Cheshire, C. H. **15**
Chester, **10**, **12**, **14**, 18
Closure, 12, 13, 35, 36, 40
Combination boxes, **56–59**, 62

Dating, 18, 19
Deakin & Francis, **58**
Deakin, James and William, **14**
Decoration, 13, **20**, 24, 25, 27, **29**, 35, **39**, 41, 43, 47, 60
Dee, Thomas William, **16**, 27
Derry, Frederick, 28
Dublin, 61

Edinburgh, 61
Electro-plating (*see* White metal)
Enamel, **15**, 42, **44**, 61

Fakes and reproductions, 61, 62
Far East, **22**, 24
Fenton, James, **11**, **15**
France, 6, **23**, 24, **36**, 43
Friction light, 6
Fur, **27**, **34**, 35, 37
Fusee boxes, 8, 10, 37
Fusees, 7, 8

Germany, 6, **17**, **18**, **27**, **31**, **40**, **51**, **56**
Glass, 42, **44**
Gloster, Joseph, **50**
Gold, 10, 11

Goldsmiths & Silversmiths Company, 54

Haseler, William Hare, **13**
Horn, **34**, 35
Hubbell, W. L., 28
Hungary, 6
Hyatt, John Wesley, 33

Ireland, **42**
Iron, 24, **37**, 47, **48**
Ironiy, 6
Italy, 8, **43**, 62
Ivory, **35**, **36**

Japan, **29**, 31, **34**, 35
Jones, Samuel, 6, 7

Kammerer, Johann Friedrich, 6

Latin-America, 8
Leather, **36**, **37**
London, 6, **7**, **16**, 18, **37**, 41, 43, **59**
Lucifer, 6
Lundström, 8

Macintosh, Charles, 41
Manchester, 41
Marks, **18**, 19
Match, 5–8, 21
Match boxes and safes, 8
Mole, F. W., 30
Mordan, Sampson, 43, **59**, 61
Mother-of-pearl, 37, **38**, **56**

Needham, Walter, **10**, **12**
Novelties, **27–31**, 45, 61

Ochs, F., 28
Opening mechanisms (see Closure)

Papier mâché, 38, **39**
Patents, 6, 7, 13, **19**, 20, 24, 28, 30, 31, 59
Pewter, 25
Phillips, Alonzo Dwight, 7
Phosphorus, 6, 7
Pinchbeck (see Yellow metal)
Plastic, 34
Portugal, 8, **18**
Presentation, 15
Preshel, 6
Prices, 60

Roemer, 6

Safety match (see Match)
Salmon & Gluckstein, 31
Sauria, Charles, 6
Scotland, **42**
Shapes, **12**, 13, 18, 24, 27–31, 38, 40, 41, 46, 51, 57, 61
Sheffield, **10**, **12**, **14**, 18
Silber, A. M., 34
Silver, **4**, **5**, **7**, **9–15**, **17**–21, **32**, 36, **37**, **39**, 43, **50**, **54**, **55**, **58–61**
Silver plating, 25, **28**, **30**, 32

Sizes, 14, 20, 47
Smith, Andrew and William, 41
Sorrento (see Italy)
Souvenirs, 41–**44**, 49, 54, 61
Spain, 8, **39**, 40
Sports trophies, 14, 15, **16**
Steel, **24**, 25
Stone, 38, **39**
Straw-work, **39**, 40
Striker, 12, 14, 25, 27, 32, 35–**37**, **47**
Sweden, 8
Switzerland, **42**

Taylor, Alfred, **4**, 12
Tiffany & Co., **20**
Tinder-box, 5
Tinder cord, **16**, 18
Tortoiseshell, 42

Unite, George, **5**
United States (see America)

Vesta, 7, 8
Vesta box, 8
Vulcanite, **40**, 41, **51**, 59, 61

Walker, John, 5, 6
Whitehead & Hoag, 47
White metal, **25**, **26**, **29**, **31**, 43, **46**, **49**, **51**, **52**, **56**, **57**, 61
Wilson & Gill, 59
Wood, 41, **42**, **43**

Yellow metal, **26**, **39**